Inspired Thoughts

By

Sky Boivin

I Promise

I stopped by your grave yesterday.
I was just passing through.
As I got closer to the cemetery,
I pulled in and drove up the driveway.
I found the faucet with no problem.
And I found you with no problem.
I wiped off the grass clippings.
I put my fingers to my lips
Then touched your name lightly.
It feels like a lifetime.
But, it has only been a little over four months.
Has it really only been that long?
And yet, it still feels like yesterday;
That my heart was ripped out to the news of you going away.
It hurts a little less each day.
But, there are other days that just feel worse.
I know it will take time.
I know I have to keep fighting.
Your profile pops up on my events each and every time;
These are the days that the knife twists just that much deeper.
I know I will survive this;
Somehow, in time.
I promise that I will Always Keep Fighting
Through this and through life.
But, seeing your name on the stone,
In the ground.
That.

That is more real.
That says I am no more.
I don't want to be that.
I don't want that fate.
Not yet.
There is too much still to do.
I promise that I will
Always Keep Fighting.
Keep fighting through this;
And through anything else that comes my way.

 8.2.2015.

My Silent Rejuvenation

As a small child, I was always terrified of the thunderstorms.
My grandmother would say it was just God bowling;
That the thunder was his ball rolling down the alley
and the lightning strike was when He got a strike.
Gram is always big on bowling; even to this day.
As I got older, I would turn my desk into a fort
And hide with my stuffed animals until the storm passed.
The feeling of the thunder rattling through the walls.
And the floor of the house would pulse through my every fiber.
Now, as an adult, I love the thunderstorms.
I wait excitedly for the energy to rumble through.
The energy change as it slowly travels in.
It is like a rejuvenation to energize my spirit and my soul.
I love the feeling of that energy which comes from them.
I welcome that energy into me.
I welcome it into my soul.
I now dance with those very thunderstorms
I was once so scared of.
I stand within those drops and smile.
I used to be terrified of the thunderstorms.

<div align="right">4/26/2015- 4/30/2015</div>

Words To Describe

Words couldn't describe this place, this pond.
Words on paper just wouldn't be able
To capture the real beauty
That nature has provided.
Or the way I feel sitting here
In the spring and summer seasons.
To describe how splendid it was
To see the wood-duck
And it's mate in that pond.
Along with their ducklings.
How magnificent that
duck looked with
his brilliant green head,
going into the water when
I had arrived.
And how the others
Followed him to
The farther part of the pond.
How cute those ducklings
Had looked! I had
Never seen such a
Sight right before
My eyes! They were
Not afraid of me; and
Nor I of them.
But, I sat there,
Watching them, and
Soon enough they
Came back toward me!
And finally, I had gotten up to leave

And I haven't seen them since.
But nothing could
Describe how I had felt.
Nothing,
Nothing at all.

 July 10, 1996

My Inspirational Earth

The earth is my inspiration for my creations on paper.
The earth is my soul inspiration for my life. The mist and fog settled on the reservoir sets my spirit free. The roar of water rushing down the waterfall sets my mind to thinking.
The fog on the land, although is capable of rich thickness at times, is very pleasant and welcoming at other times.
The mist at times captivates the real beauty in the least likely places.
Place of such splendor and peace sets my inner self at ease and sends my thoughts moving. I become more aware of the charm that one place holds, that one would not find just passing through once. For the most pleasant and charming things are the little things you find under your own nose.

January 3, 1997

My Inspirational Universe

My inspirational earth,
My inspirational universe.
Everything becomes so very
special to me.
From everything I see with
mine own two eyes, and hear
with mine ears, to smelling
with my nose.
Makes me able to feel with my spirit.

I love my outdoor
surroundings. The trees, water,
woods. Even the animals.
Especially the animals which
Have learned to live in harmony
with each other. And I sometimes
Wonder, why can't we all live that way, too?

 January 24, 1997

The Cardinal

It had snowed yesterday.
But this morning, it was
raining. The land was in a
sheer blanket of snow, ice, and
rain. The trees were
still their rich green, but
now kissed with ice.
And when I woke up
And looked outside this morning,
I saw it.
A beautiful red cardinal,
Sitting on one of those branches
outside my window.
I sat there and watched him.
He did not fly away. But, if
He had, I knew that he would return.

January 25, 1997

<u>Why did you go?</u>

With the snow falling down,
And the sky bright from the coming spring.
Why did you have to go?
I never had the chance
To say what I had to say.
I guess I was t o blame.
I took it for granted
That you would always be there.
I never realized just how much
I loved you
Until it was too late.
And you were gone from my life forever.
But your memories live on in me.
They will always live
For as long as
I am around,
And as long as this paper will last,
So that all others can remember
You, too.
I remember Wednesday evenings at Gram's
Before you both went bowling.
Then you moved to Ohio and got sick.
Too sick to go on anymore.
So you said good-bye to the world you knew.
Then you were gone from our lives.
But when you left,
Part of myself went with you.
For you died on my friend's birthday,
And fur days before my own.
I still don't really understand why this
Had to happen.
All I know is that you are gone and I miss you.

<div style="text-align: right;">March 11, 1997</div>

Inspiration Lost

My hands are cold
But the rest of me is warm.
Up here on the fourth floor,
It's nice and warm.
I haven't written,
For such a long time.
Why is that?
It's not because
I do not have the time.
I just have not been…
 Inspired.
Where has all of my
Inspiration gone to?
Has it flown away?
Is it resting?
Taking a long needed
Nap and vacation?
Where is it?
Where has it gone?
Will it be coming back?
Or have I lost it for good?

 September 5, 1997

Home Again

Lovely day out for a walk.
Sit at my pond.
What's this?
Could it be?
Is it so?
Why yes-
Tears in my eyes.
But only for a moment.
My wood ducks have returned
To me
To my pond, once more.
The male with his brilliant green
head and neck.
Dipping under the water's surface.
Searching for food.
The female-
Her assortment of browns
So elegant and calm.
Neither one notices me.
"Oh please"-
I plead-
"do come this way,
I don't mean you any harm,
Just a closer look."
They continue to swim
Further to the swamp.
The swamp further away from me.
But I don't care.
They have returned for the spring
And summer months.
I do so hope they will return
Year after year.
Rather than every few years.

Such a great splendor
And ease-
To see them once more.

April 5, 1999

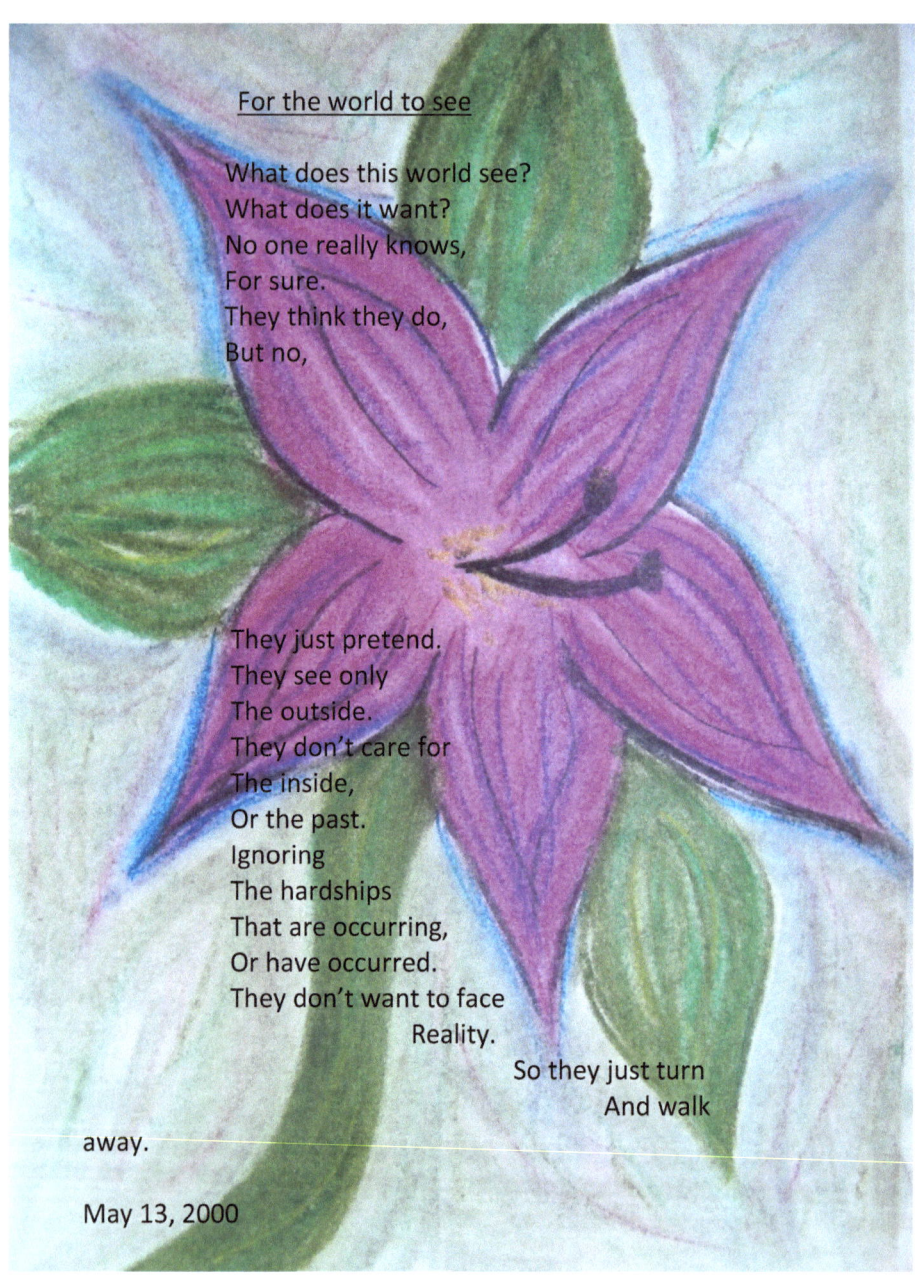

For the world to see

What does this world see?
What does it want?
No one really knows,
For sure.
They think they do,
But no,

They just pretend.
They see only
The outside.
They don't care for
The inside,
Or the past.
Ignoring
The hardships
That are occurring,
Or have occurred.
They don't want to face
 Reality.
 So they just turn
 And walk
away.

May 13, 2000

My Silver Lining

Why is it that I have to fight for everything that I have?
Why is it that every two steps forwards I take,
I am instantly sent five steps backwards?
Every time it seems like a silver lining is finally upon me,
It is gone just as quickly.
My hopes are patched together with tattered scraps of cloth and pieces of thread;
tied together to form one long strand from all of my struggles in this lifetime.
Why does everything have to be a struggle for me?
When will there be a silver lining that will stay for longer, if not for good?
I don't want to have to keep fighting for what I have anymore.
Not as the constant struggle that it has been, at least.
I Always Keep Fighting.
But even that phrase grows weary as the days grow longer.
Where is my silver lining?

4.30.2015

Inspired Thoughts | Sky Boivin

A Legacy of Love

Today was touching in so many ways,
Today was heartwarming and sad in both ways.
Many of us gathered today in love,
many of us gathered today to say good-bye.
There was laughter and tears,
sorrows and joys.
Quiet memories and cheerful, tearful words.
You touched many in your years,
and it showed in our gathering.
The faces that lite up at a mention of a memory,
brings smiles all around.
Tearful hugs in the end,
and playful pokes when we went to you that one last time.
You left a Legacy of Love in that room,
and for that you shall always be remembered.
For that, you will always be cherished.

March 2015

A Part of Your Game

Why do you persist in kicking this horse while she is down?
Why do you insist on training her?
In testing her?
What more is there to be learnt?
This horse grows weary of your games.
This horse grows tiresome of your ways.
Enough is Enough.
Cease this game of yours.
I will not fall victim to your games any longer.
I am not your Plaything.
I am Morgaine LeFaye.
I command you to end this.
I know my battles to be played.
I know my role in your game.
I do not want any part of your plan.
I never asked for this.
I will not be a part of your game.

July 11, 2015

Inspired Thoughts | Sky Boivin

Time and life

Time and life

can weaken yet

strengthen a person's soul.

Just everyday hard-

ships and pressures

can send one into

utter turmoil.

But, at the same instant,

prepare them for the

next time.

March 23, 1997

Home To Avalon

The Lady must be in need of me,
She has sent Her vessel.
Her boat of long wood,
Curved at the end.
Long, curved and graceful,
Just like Her.
Has She sent for me?
Does She deem that I am ready
to return to the lake with Her?
The boat awaits,
Silent and lonely.
along the banks of a small pond.
It seems to go nowhere.
But, a vessel of Avalon
Does not need much space to travel.
As long as one is worthy enough to part the mist.
Only then, does one come to Avalon.
And to the Lady.
Home to Avalon.

 June 4, 2014

Dreams and People Go

Dreams come and dreams go.
Some stick with us and some disappear;
like the dew upon a cobweb in the morning sun.
Some we linger over and ponder
about just what they meant.
What were they trying to tell us?
Others are gone so quickly
that we can't even remember a glimpse of them.
Now just what was that one about...
we may ask ourselves.
Some are meant to stay
and others are meant to go;
like the people in our lives.
Some just quickly pass us by;
not meant to share in our lives.
While others are to remain in our hearts forever.
Some that remain, the Fates deem to cause us
pain.
Why lie?
Why pretend something that is not?
And like dreams,
we remain to ponder over these lives
that come and go at times.
Why?
What's in it to do so in this life?
What is the worth?
To learn and grow?
To advance further in the knowledge
of how people can be?
Dreams come and go from the night
as people come and go from our hearts.

Sept. 29,2010

Drag race disaster

Below the fire-lit sky,
is the clutter and remains of an accident.
One which could have been avoided.
A sign ripped apart,
a light post torn from its' home.
Trees raped of life.
Along with a nine-teen year old.
Drunk, drag racing?
All I am sure is that the vehicle
was doing a hundred mph.
Lucky that no one else was hurt.
That night,
brave souls in chaos.
Some put out fires while others called 9-1-1.
Still others, saved lives.
Normal people with normal lives.
People who do not get recognized
For their everyday tasks.
They, and I know who they are.
I want to just say,
Thank you, for being you.
And for caring.
That, is what life should be all about.
Caring and helping others.

10.12.2000

Free my soul

My soul is crying to be free.
Tension still runs through my bones
from the day.
The clouds hiding behind barren trees.
All unmoving before my eyes.
While the sunset light peeks through the clouds.
I try to calm my over-sensitive emotions;
My over-tired emotions.
Before,
I could take off to my pond, the cliffs, or wherever.
My spirit cries for that once more.
The light behind the trees grow ever more red
as the sun goes down more.

4.17.2001/8.1.2015

The Memory

Dear diary, Dear world.
Come a long way weary.
Bits and pieces of my past creeps in when I least expect.
Little things spark it up again.
When I plea to flee.
I used to, anyhow.
I am unsure whether I do anymore.
The hand flying;
Not sure why anymore.
It's in the past;
buried deep beneath the sands of time.
Controlling streetlights,
can't go anywhere.
When with the other parent,
I had to be bad.
Don't behave; don't smile for the camera;
Don't have fun.
I would wear the clothes that were there;
Not the ones in the bag.
Sunday, mess up the ones in the bag;
to make it look like they were worn.
Take all of the vitamins the morning back.
Ready my mind to tell my lies.
What does He want?
No matter what I do, the hand flies.
Get sent into the corner with no supper;
Until I tell.

The little one sitting, watching.
Were you bad?
 Yes.
Did you smile for the camera?
 No.
Did you have fun?
 No.
What did you do?
 (What do I say?!)
The agony of the thought.
Do I say this?
Do I say that?
Hair covering a bruised cheek while standing in line.
A hand rests on my shoulder.
Come on, let's go.
(No school today? But I was having fun.)
I know, now.
He was afraid.
Afraid of getting caught.
(You actually have feelings? I never would have thought.)
Fight to go with your mother, RUN.
Run, I did; behind the chair.
Saying I don't want to go.
He sat there and said,
"Why are you acting like this?"
Giving me a look all the while.
(But you TOLD me to; why are YOU doing this?)
Years later; waking up in a cold sweat.
Just another dream; I hope.
He came to get me in the dream.
Already got the other.

Me, fighting him to get away.
Actually standing up to him?
(Not in real life.)
My friends (I'd be too scared)
And classmates; help to get away from him.
(Why do I keep having this dream?)
To this day, if one pays close enough attention;
One will notice.
If you make a quick motion;
I'll see it and snap my head to look at you.
Look with eyes that spell,
"WHAT ARE YOU DOING?"
Not so often anymore; am I so jumpy.
It is unbelievable,
that he still tries to come back into my life.
I don't want him here.
I wish he'd just be gone.

4.5.1999

My Heavy Atlas

I feel like the weight of the world is upon my shoulders.
Heavy and unyielding.
Never ceasing.
This must be how Atlas feels;
Standing there never-endingly holding
the world upon his shoulders.
Never allowed to rest his aching body.
The slightest shift that Atlas makes, I feel.
Each shake and tremor of the
continental drift makes me ache.
Every severe earthquake causes turmoil within me.
He has held the same position for three millennia.
Now he needs to shift his position.
It creeks and groans as he does.
Will this weight upon my back ever be lifted?
One may never know.

10.23.2013

Soul Sisters

Silent whispers in the darkness.
An unknown change foreseen.
Ripped apart, yet not so far away.
Just towns away, for fifteen years.
I would lie awake late at night;
Crying into my pillow and my unicorn.
 Wishing upon the stars.
"Where are you? I miss you"
Fifteen long years later,
Our prayers have been answered.
I cry upon your shoulders;
And whisper in your ears,
"I've missed you. I've never forgotten you.
I love you, my soul sister; always."

10.10.2003

Then to now

People say not to hold onto the past.
That the past is not important.
But, you shouldn't have to live in the past.
It's okay to remember things.
But just try to keep in mind;
It happened THEN,
Not NOW.
You can't change the past.
But, in fact, with the ability to remember,
You can try to make sure certain things
Don't happen again.
That's the wonderful thing about the past.
If we remember it,
We can look back and see how to change
The Present.

2.12.2001

Time To Show The World

I have pushed my dream to the back burner for too long.
It has been long enough.
Now, is the time for me to reach for the stars within my heart.
I long to write with every fiber within my heart and soul.
I know of nothing else.
I know only of the flow of the ink from the pen;
The words flowing rapidly, as the pen glides feverously along the pages of my journal.
Never planned; but always flowing, always feeling.
Now, is the time to gather all of these into a collective thought.
Now, is the time to share with the world.
Now, is the time to climb that higher tree branch; without fear of falling.
Now, is the time to take that leap.
It is time to pull my dream to the front burner and bring it to the table.
Now, is the time to show the world me.

July 21, 2015

Free To Be Me

For the first time, I see.
For the first time, I stand tall.
For the first time, I know who I am.
I stand taller from those who love me.
I stand taller from their support.
I stand taller because I see.
I see their love and support radiate to me.
I see their belief that I can do this.
I see their words become truth as I grow.
I know I can do this
I know they believe in me.
I know that is all I need to do this.
For the first time,
I am free to be me.

July 21, 2015

If I Disappeared

What would happen if I just disappeared tomorrow?
Would anyone even notice;
would anyone even care?
What would happen if I was just not there?
What would one say to that day?
Am I of any importance to anyone?
Do I make a difference in anyone's life?

Memories of my childhood roll around in my head.
The smell of a fire burning two houses over,
Bring these memories around tonight.
The thought that my birthday party is a bust
Yet again this year brings these thoughts rolling in.
Nothing will come of these thoughts;
So don't worry your pretty little heads over me.

I will just stay lost in these thoughts.
Forever trapped; forever drowning.
Could I have saved this person?
Could I have helped them?
Why did I not listen to my gut?
When will I learn?
Would it have even mattered?

Sadness of loss brings me deeper into my thoughts.
Loneliness drags me deeper still;
Until it is too much to bear.
Frustration boils me into overload.

The tears brim my eyes
As I travel deeper still.
I hold out as long as I can.

The voice of my husband resonates from inside,
"No one is coming."
These words echo in the back of my head.
But it is early yet still, they have time;
I try to assure myself.
I must continue to fight my running thoughts.
I must not give in to these fears.

What if I became nothing like you want?
No matter how much I bend;
No matter how much mud I get dragged through.
I must not break; even though I never asked for this.
Nothing I do is ever good enough.
I am looked upon as a complete failure.
You do not want into this head of mine.

What would happen if I just disappeared;
Into nothing that they see me as?
Would anyone even notice;
Would anyone even care?
Don't you worry your pretty little heads over me.
These thoughts are mine and mine alone.
They are too dangerous for you to even care.

9.12.2015

One Last Dance

After the food had been served and all have been feed,
the tables are moved to the outskirts of the tent.
The Maid of Honor stands in the middle of the now opened space.
Words of love and friendship and family,
echo from the microphone in her hands.
Tears of love and happiness fill our eyes.
Soon, the music starts.
Slowly, we flock to the now dance floor.
As we go on with our dancing and the fun continues;
as the night draws upon us all,
I feel even more happiness and love surround me.
So much fun had together; just being in each other's company.
Then, it dawns on me later on.
You were there with us in spirit.
You were out there on the dance floor.
The happiness I felt was not just mine and those around me;
It was you; our beloved Angel.
You were embracing your nieces once more in dance.
Thank you for sharing the night with us.
Thank you for one last dance.

9.24.2015

www.ingramcontent.com/pod-product-compliance
Lightning Source LLC
Chambersburg PA
CBHW041612180526
45159CB00002BC/818